Arneson and the Object

Arneson and the Object

Curated by Leo G. Mazow

Palmer Museum of Art, THE PENNSYLVANIA STATE UNIVERSITY, UNIVERSITY PARK, PENNSYLVANIA

Arneson and the Object

This catalogue is published on the occasion of the exhibition *Arneson and the Object*.

Exhibition itinerary:

Palmer Museum of Art, The Pennsylvania State University
February 10–May 16, 2004

Greenville County Museum of Art, South Carolina
July 3—August 29, 2004

George Adams Gallery, New York
October 1–November 13, 2004

Designed by: Abby Butler, Penn State Department of University Publications
Printed by: Payne Printery, Inc., Dallas, Pennsylvania
Distributed by: Penn State University Press

Photographic acknowledgments: Richard Ackley, Penn State Campus Photography—cat. nos. 1, 2, 4, 5, 8, 11–14, 20, 21, 26–28; Schopplein Studio—cat. no. 7; Lee Fatherree—cat. nos. 10, 15, 16, 18, 19, 22–25; Lee Fatherree, courtesy the Palo Alto Art Center—Fig. 2; Adam Reich—cat. nos. 9, 10, 21.

This publication is available in alternative media on request. Penn State is committed to affirmative action, equal opportunity, and the diversity of its workforce.
Produced by Penn State Department of University Publications U.Ed. ARC 04-233

Library of Congress Control Number: 2003113961
ISBN 0-911209-61-1

PENN STATE
1855

FRONT COVER: Cat. 27. Robert Arneson, *Brick with Hand of*, 1991, modeled 1972, bronze, 9 1/2 x 8 1/2 x 4 inches. Estate of Robert Arneson.

Contents

Acknowledgments

Arneson and the Object has benefited from the generosity and instrumental efforts of several individuals. On behalf of the Palmer Museum of Art, I would like to extend my deep gratitude to the exhibition lenders: Estate of Robert Arneson, Benicia, California; George Adams Gallery, New York, New York; Patti and Frank Kolodny; Prudential Insurance Company, Newark, New Jersey; and the anonymous private collectors.

My colleagues at the Palmer Museum of Art have offered integral support, without which the present exhibition could not have been organized. I would like to give special thanks to Beverly Balger Sutley, registrar, for her masterful handling of the complicated packing, shipping, and insurance details; Jan Muhlert, director, for believing in this project, offering crucial encouragement, and enabling me to

travel to the Estate of Robert Arneson in Benicia, California; and Jana Lee Emmer, graduate assistant, for helping to transcribe the interview on pages 32–42. I thank Dick Ackley, of Penn State Campus Photography, for his superb photography of several works of art in this catalogue. I also thank Abby Butler, Sarah Juselius, and Kerry Newman, of Penn State Department of University Publications for their instrumental efforts in the production of this piece.

Special thanks go to Sandra Shannonhouse, the artist's widow, and Stephen Kaltenbach, Arneson's first student, for meeting with me in Benicia and facilitating the interview that appears in this catalogue. Ms. Shannonhouse has supported every aspect of this exhibition and I express to her my deep gratitude for making works in the Estate of Robert Arneson available for study and exhibition. Of all those providing assistance in my research and search for works of art, I would like to single out George Adams and Kelly Lindner, of the George Adams Gallery, who have most generously given their time and expertise to this project.

Like many students of Arneson's work, I have benefited enormously from the scholarship of Neal Benezra, Beth Coffelt, Robert Hobbs, Jonathan Fineberg, and Donald Kuspit. I would also like to acknowledge the insights and collegial assistance of Roger Hankins, Iris and B. Gerald Cantor Art Gallery, College of the Holy Cross; and Signe Mayfield, Palo Alto Art Center.

Leo G. Mazow, *Curator of American Art*

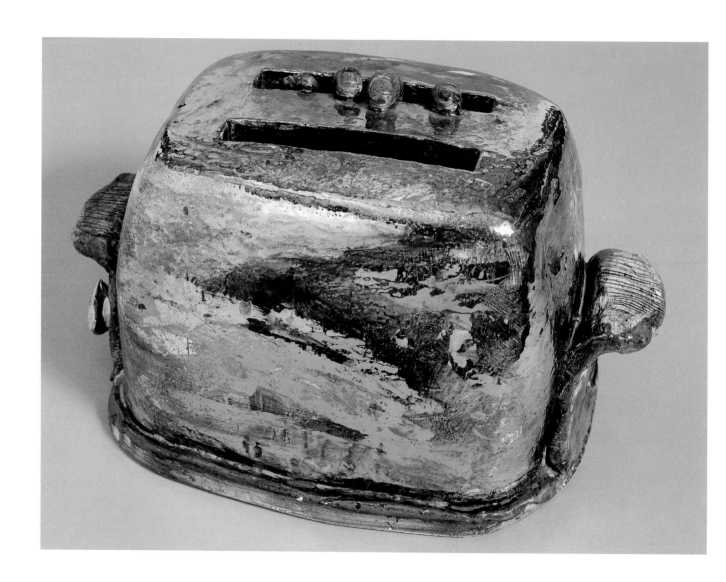

CAT. 8
Toaster, 1965, glazed
ceramic, 8 1/8 x 14 1/2 x
9 3/4 inches. Private
collection, New Jersey.

Arneson and the Object

by Leo G. Mazow

Batteries, BINOCULARS, books, BOTTLES, bricks, chains, CLOCKS, coffee cups, coins, COOKIE JARS, DISHES, duffle bags, FRAMES, goggles, guns, half-eaten pastries, LAMPS, picture hooks, pipes, PLATES, rolls of toilet paper, ROSE-STUFFED FLOWER POTS, saddles, SCALES, sewing machines, shoes, SIX-PACKS, street signs, teapots, telephones, televisions, TOASTERS, toilets, TOOTHBRUSHES, trophies, typewriters, and WAR-RAVAGED URNS. This list represents a partial inventory of objects providing the primary subject matter in Robert Arneson's (1930–1992) sculpture, paintings, drawings, and prints.[1] Whatever else Arneson's work may be about, it is also about the object. From his Cold War-era "Funk" mode through his more trenchant, culturally charged approach in the 1980s and early 1990s, a profound understanding of commonplace materials as expressive devices informed his artistic practice.

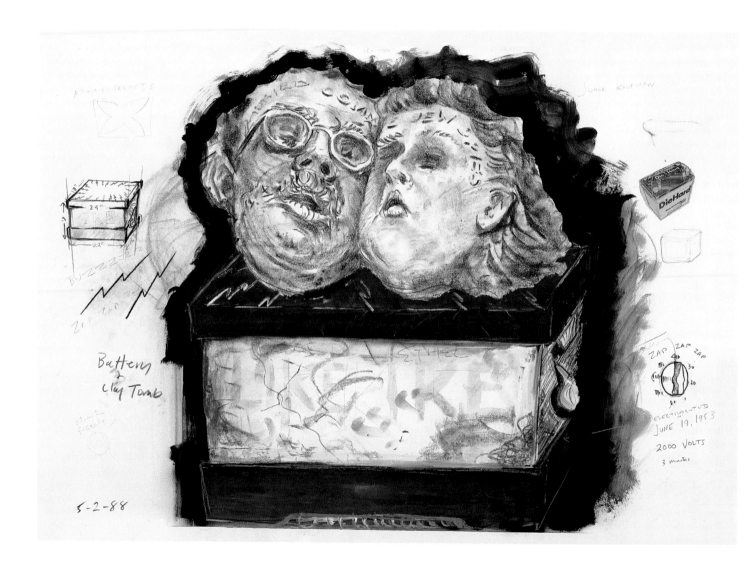

CAT. 23
Julius and Ethel with Battery, 1987–88, mixed media, 30 1/4 x 44 1/2 inches. Estate of Robert Arneson.

O BJECTS, broadly considered, provided the foundation of the artist's exploration into matters of acute social and personal concern. *Toaster*, 1965, illuminates the manner in which Arneson exploited the incisive and provocative potential of ubiquitous and seemingly innocuous articles from everyday life (cat. 8). On first glance we see a life-size clay facsimile of the appliance, modeled and glazed to suggest the streamlined curves and reflective metallic sheen of a typical 1960s American kitchen.[2] Closer inspection, however, reveals fingertips emerging from one of the bread slots, anxiously gripping the toaster's silvery exterior. Arresting our gaze somewhere between aesthetic awe and historical horror, the side discloses a small, encircled swastika. *Toaster*, then, is much more than a toaster—a small thing, it nonetheless engages the larger whole of the Holocaust, as well as the sublime loss and struggle for survival entailed in that genocide.

With *Toaster* and other pieces in this exhibition, Arneson extracts meaning from an artwork's object-ness; the quiddity, or thing-ness, is part of the message. Several pieces in this exhibition can be interpreted as vicious puns on the very notion of artwork-as-object. Art historian Robert C. Hobbs has aptly observed that *Toaster*, for example, addresses "the horrors of packing and processing people so that they were transformed into objects."[3] In

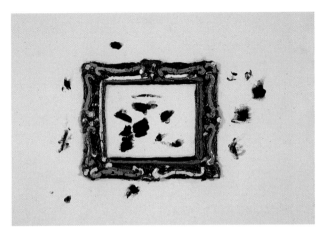

Arneson's pictorial universe, historical consciousness is a priority, but so is the manner in which we—who are left only with object reminders of that past—take in the lessons of history.[4] Much like his later works addressing the trial and execution of Ethel and Julius Rosenberg, from 1987–88, *Toaster* is a *memento mori* in an otherwise banal world of consumer goods, a remembrance of death and a reminder of the preciousness of life (cat. 23, 24).

In similar fashion—albeit more sexually than politically incisive—*Binocular*, 1965, is more than a pair of binoculars (cat. 3). With the lens pieces depicting eyeballs on one side and female genitalia on the other, *Binocular* does not address vision per se, but rather the reductive and demeaning capability of the male gaze—and the duplicitous

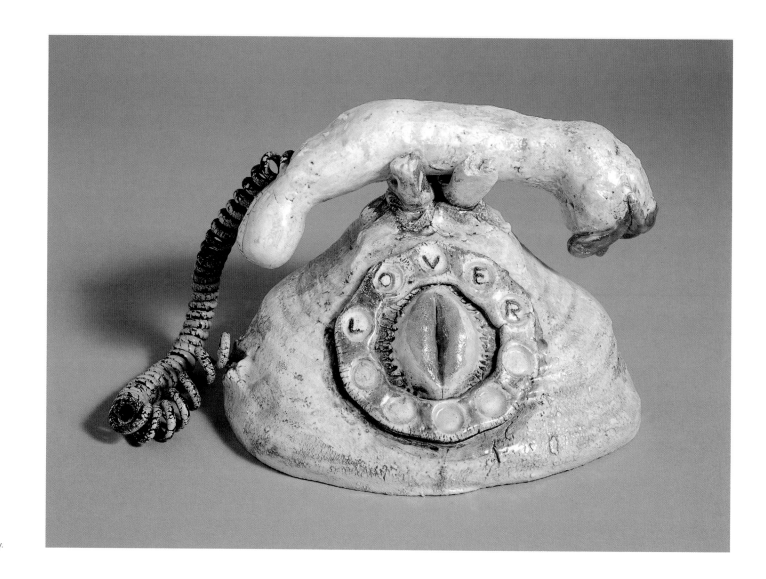

CAT. 4
Call Me Lover, 1965,
glazed ceramic and
mixed media, 8 x 11
x 9 inches. Private
collection, New Jersey.

nature of any gaze. Female sexual organs also appear on the face of the telephone in *Call Me Lover*, 1965, relegating sexual identity to a mere object, and creating a work that is less about modern communication than the conflation of electronic media and carnal desire (cat. 4). Here, as elsewhere, Arneson's intentions are unclear—is he reveling, perhaps critiquing? Donald Kuspit is among those writers to point out that whatever Arneson's stance, by sexualizing these inanimate articles, he nonetheless "creates life in dead objects."[5]

Alongside works like *Pee Cola*, 1964, *Toaster* also demonstrates the artist's alliances with, but sure breaks from, contemporary Pop Art (cat. 1). Rivaling the machinations of a post-war consumer culture that equated more with merrier and name brand with worth, Arneson joined Claes Oldenburg, Jasper Johns, Andy Warhol, and others of his generation in representing a world of mass-produced wares.[6] Like the latter individuals, Arneson took as his subject unabashedly middle-class products designed with rich, bold coloration. And as with Pop objects—e.g., Oldenburg's soft toilets, Warhol's Brillo boxes, Johns' ale cans—Arneson's articles challenged the grandiose subject matter and heroic scale of 1950s Abstract Expressionism.

But where Pop treaded a fine line between social celebration and cultural critique, careful to remain coolly de-

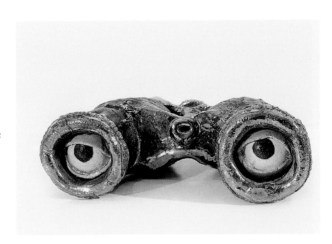

tached from both, Arneson's expressionism was formally and iconographically forthright. To be sure, *Call Me Lover*, *Flush*, 1965, and other works from the 1960s elevate vernacular commodities to the level of fine art in a manner consistent with Pop (cat. 5). Yet, with vigorously modeled surfaces revealing everywhere the traces of the artist's hand, and replete with humorous and horrific plots alike, these pieces are quite a distance from Warhol's self-consciously insipid, narrative-less subjects. Formal qualities probably suggest the most apparent difference between Arneson's expressionism and Warhol's Pop: the variegated textures and painterly surfaces of the former replace the smooth lines, localized colors, and emphatic contours of the latter.

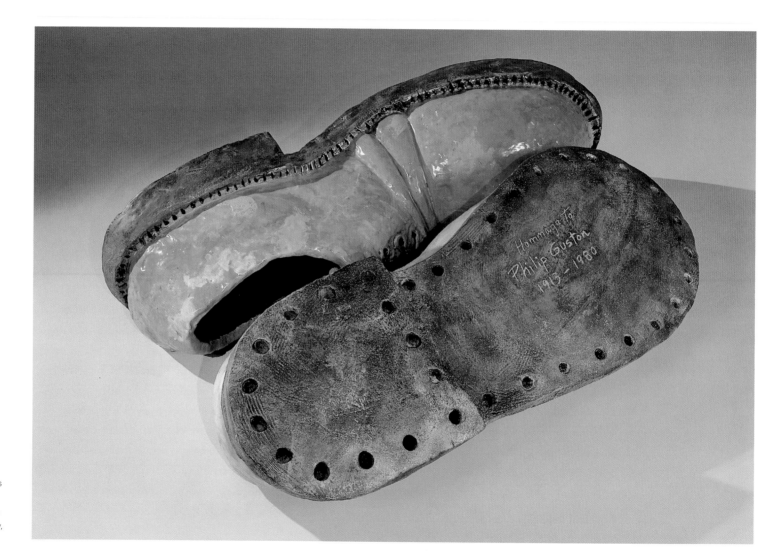

CAT. 15
Homage to Philip Guston, 1913–1980,
1980, glazed ceramic,
11 1/2 x 16 x 38 inches
(1), 13 1/2 x 18 x 42
inches (r). Private
collection, courtesy of
George Adams Gallery,
New York.

CAT. 1
Pee Cola, 1964, glazed
ceramic, 18 3/4 x 9 3/4
x 6 1/4 inches. Private
collection, New Jersey.

Arneson's immersion in the world of objects could
scarcely have been more out of step with contemporary
critical declarations of artistic quality. Siphoning value
from the vernacular and finding artistic fodder in the
protracted story line, Arneson embraced the very stuff
that the influential formalist critic Clement Greenberg
dubbed kitsch. Greenberg and his modernist protégés,
including such powerful voices as Michael Fried and
Hilton Kramer, deemed the introduction of external
referents (materials from everyday life, anything outside
the picture plane proper) to be artistically inappropriate.
Museums, magazines, journals, and classrooms around
the world articulated a common modernist-formalist
sentiment: politics, religion, and diary-like story lines
violated the purity and immanence of the visual arts.[7]
With his ceramic versions of common household articles,
Arneson effectively critiqued a twentieth-century
modernist philosophy that equated artistic quality with
the erasing of the "everyday" as subject matter.

Michael Fried may have most accurately summarized the
formalist value system when he wrote in his now-classic
essay on minimalism, "Art and Objecthood": "Art degen-
erates as it approaches a condition of theatre."[8] Arneson,
who had a keen awareness of the Greenbergian tradition,

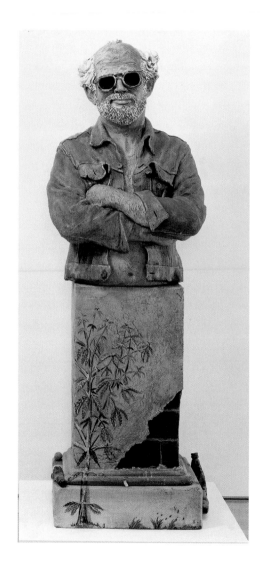

FIG. 1
California Artist, 1982,
stoneware with glazes,
68 1/4 x 27 1/2 x 20 1/4
inches. San Francisco
Museum of Modern Art.
Gift of the Modern Art
Council, 83.108A-B.

enlisted objects as so many *dramatis personae* in his theatrical environments.[9] With dramatic and, in places, sensationalized plots playing out on alternately viscous and crackly clay stages, Arneson's objects introduce a sort of ceramic theatre, one that violates the tenets of high modernist ideology.

Arneson's antiformalism did not go unnoticed by Hilton Kramer, who in a 1981 review remarked that the artist did not understand the finer points of "satire," and that his "provincial" art was "limited in ambition."[10] Moreover, Kramer observed, in violating the sacrosanct realm of art, he represented the degenerate culture of California. Kramer's review, however, encouraged Arneson to rethink his use of satire, compelling him to make what is probably his best-known work, *California Artist*, 1982 (fig. 1). The laid-back, sunglasses-wearing artist is himself transformed into an iconic West Coast object situated atop a pedestal, flanked by marijuana plants, exposed bricks, and a partially empty bottle. Objects like bricks, bottles, and potted plants are the primary focus in several works in this exhibition, but their inclusion in *California Artist* demonstrates the manner in which Arneson conceived of objects as potential media, much as other artists might enlist oil on canvas.

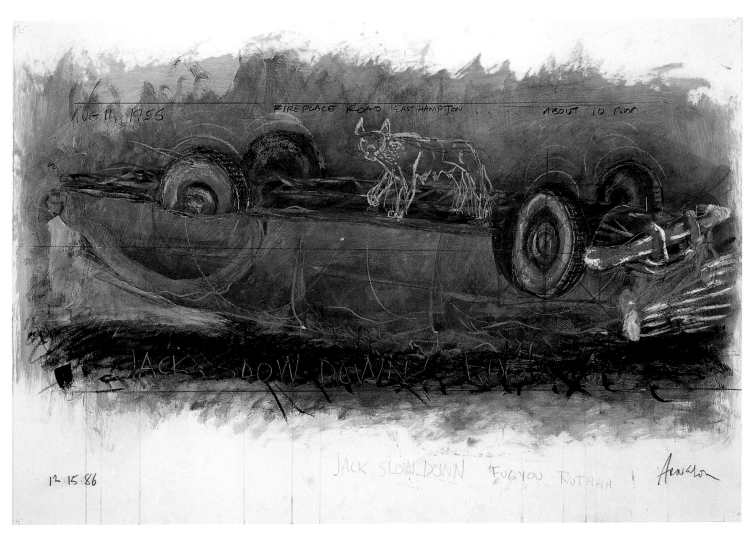

AUG 11, 1956
FIREPLACE ROAD EAST HAMPTON ... ABOUT 10 P.M.
JACK SLOW DOWN FOO
12·15·86
JACK, SLOW DOWN FUGYOU RUTHAH !

CAT. 21
Jack—Slow Down,
1986, conté crayon and
charcoal on paper, 30 x
44 1/2 inches. George
Adams Gallery, New York.

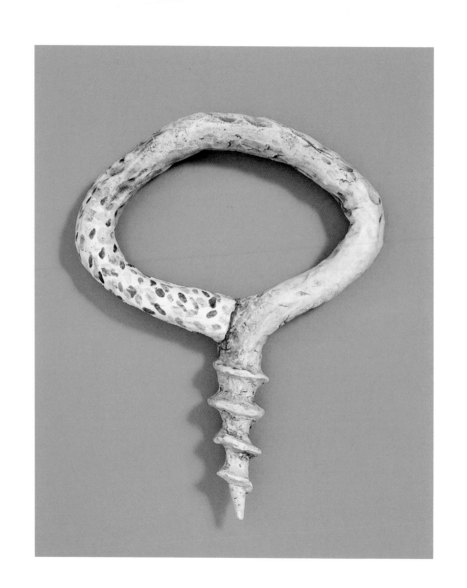

CAT. 12
Eye Screw, 1971,
glazed ceramic,
11 x 8 1/2 x 1 inch.
Private collection.

CAT. 13
Untitled (coffee cup),
1974, watercolor on
paper, 11 x 15 inches.
Private collection.

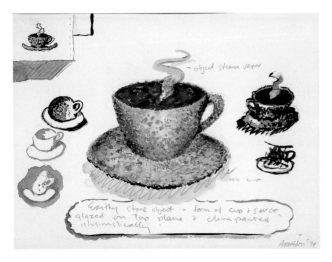

Earlier, in works like *The Critic*, 1964 (Estate of Robert Arneson), with its missing head and exposed testicles, the artist had commented on the guileless shortsightedness of the critical profession. The spoof-reaction to Kramer, however, was part of a broad pictorial and philosophical strategy to bridge time-honored gaps between high and low, art and craft, and meaning and context; and Arneson's leitmotif objects proved integral in this endeavor. He frequently enlisted art materials and supplies—clay, hooks, screws, frames—to establish the flimsiness and instability of the artistic enterprise in general. *Untitled* (Frame #3), 1968, contains nothing but smudges within the frame depicted (cat. 11). The negative space of the bare canvas is no match for the richly colored, thick impasto of the painted frame. Similarly, with its pointillist ornamentation and dappled clay surface, *Eye Screw*, 1971, as a piece of hardware, is surely as aesthetically viable as anything that may hang from it (cat. 12). The piece—with the title a homonym for "I screw"—also suggests a capricious analogy between artistic and sexual activity.

Arneson explored the high-low dichotomy with full force from the mid-1960s through the mid-1970s. In works like *Gold Lustered Rose*, 1966, and *Flower Pot Inside*, 1967, he experimented with both scale and the idiosyncratic nature of vision (cat. 9, 10). In so doing, he granted flowers and "flower painting" a gravity and artistic worthiness, in contrast to their time-honored position at the bottom of the hierarchy of genres. With his many dirty dishes and coffee cups, Arneson exposed the false dichotomy between the refined and the functional (cat. 13). Along with his brick series—which may represent his most fully articulated defense of clay as art—the flowers and cookery also call into question preconceived notions of finish and polish in an exceedingly antiseptic art world (cat. 14, 27).

Some of Arneson's most expressive objects function as part-macabre/part-comic memorials to deceased artist-role models. Of particular note here are the works honoring

19

Jackson Pollock and Philip Guston. In the Pollock series, Arneson fixates on those objects—his car, his painted drips, his head—with which the Abstract Expressionist has been mythologized, and which, ironically, each in its own way, contributed to his premature death (cat. 21, 25, 26). He produced approximately eighty works with Pollock as their subject, as opposed to only a handful of sculptural objects and drawings relating to Guston—and yet these works are equally important in Arneson's oeuvre. Guston gained renown late in his career for his use of the shoe motif. Guston, van Gogh, Miró, Warhol, Joseph Beuys, and Sherrie Levine are among the many modern artists who have enlisted shoe imagery to heroicize the abject, comment on the banal and easily commodified, and probe their own identities.[11] In its exaggerated scale, bold curves, and intensely bright pink glaze, Arneson's *Homage to Philip Guston, 1913–1980*, 1980, may do all these things (cat. 15).

But it does something more as well. With Guston's life dates inscribed in the sole, the sculpture mimics a tombstone, and the text is hauntingly spare. Like an ancient grave stele, the pair of shoes dominates the ground, as if to be seen by a standing observer. In her interview for this catalogue, Sandra Shannonhouse, Arneson's widow, comments that the artist admired the folk tradition of placing backwards, upside-down shoes in a slain cowboy's

stirrups, and that she and friends placed Arneson's upturned clogs on the base of one of his pedestals when he died. Comparison of *Homage to Philip Guston* with Arneson's sculpture, drawings, and prints of Pollock's shoes, which stand erect, suggests a heightened sense of loss in the Guston memorial (fig. 2).

A long tradition, extending from steeply vertical Gothic cathedrals to Donatello's niche statues like *St. Mark* (1411–13) at Or San Michele in Florence, to Rodin's *Three Shades* atop his *Gates of Hell* (1917; posthumously cast), has made an equation between the upward gaze and the uplifted subject—as if the more we tilt our head back to look up at the work, the more exalted it is. In *Homage to Philip Guston*, by contrast, we look down, much as we do in other pieces by Arneson, including his *Scale*, 1965 (cat. 7). But the shoe—which encounters endless filth, not to mention the stench of our feet—is yet more abject. It is the most vernacular item in Arneson's inventory of objects, save for, of course, the toilet itself, another object we may look down upon, indeed sit upon, when using. For Arneson, the downward gaze is not synonymous with "looking down upon" the object.

Having migrated from the color fields of post-painterly abstraction to the shoe motif, Philip Guston was surely an exemplar for Arneson, whose art experienced a similar

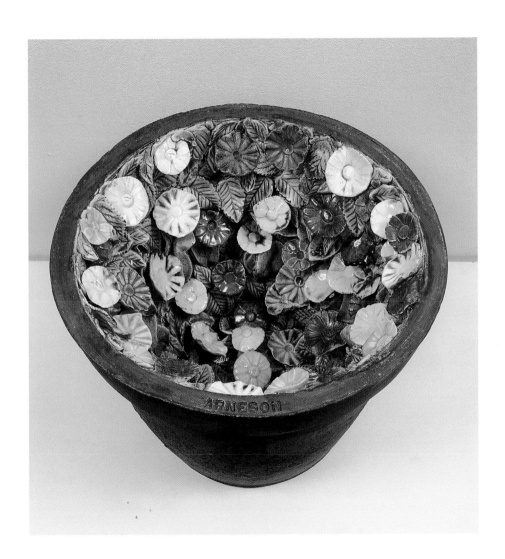

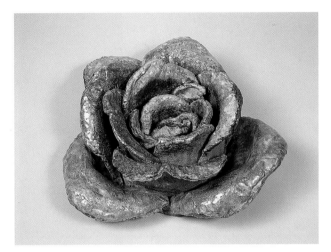

CAT. 9
Gold Lustered Rose,
1966, glazed ceramic,
29 x 24 x 11 inches.
George Adams Gallery,
New York.

CAT. 10
Flower Pot Inside,
1967, glazed ceramic,
9 x 12 x 12 inches. Private
collection, courtesy of
George Adams Gallery,
New York.

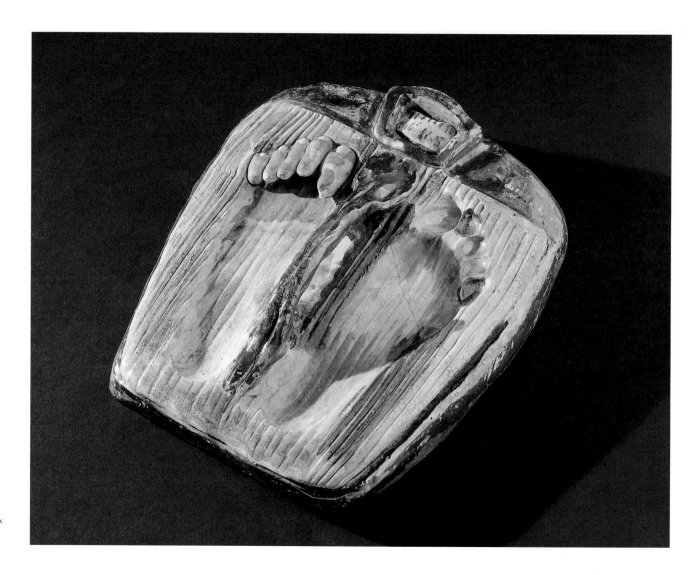

CAT. 7
Scale, 1965, glazed
ceramic, 4 1/2 x 13 x
14 inches. Private
collection.

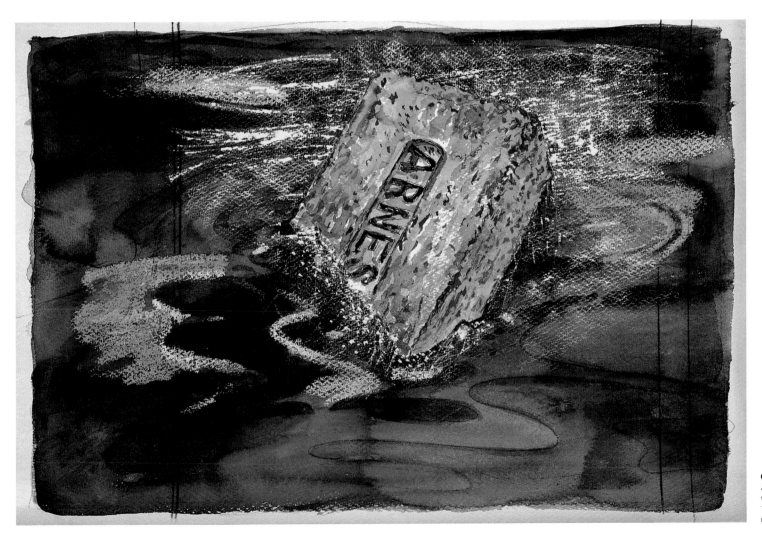

23

CAT. 14
Sinking Brick, 1976,
watercolor on paper,
12 x 18 inches. Private
collection.

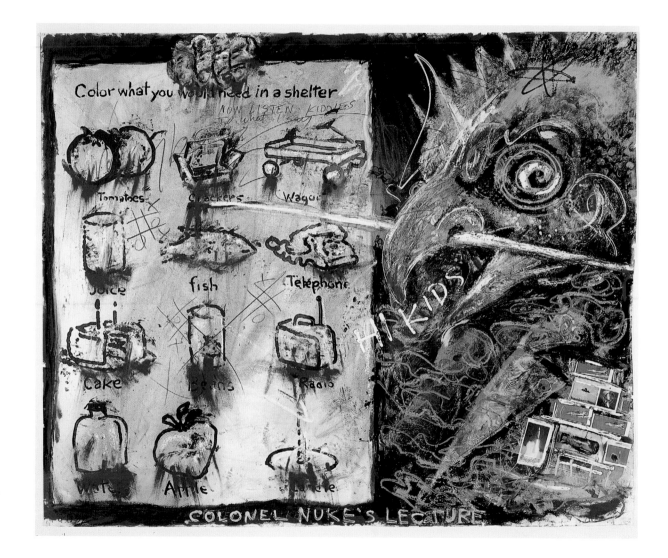

CAT. 19
Colonel Nuke's Lecture,
1984, mixed media on
canvas, 53 x 65 inches.
George Adams Gallery,
New York.

transformation from refined to vernacular in the early 1960s. For both artists, the shoe may have signified some underlying truth of everyday existence, as well as the role of art in documenting that truth. Arneson's shoes are an "homage," then, insofar as they enlarge the size and heighten the pink tones, and thereby make high art from the mundane. For Arneson, as for Guston, the shoe points to life at its most honest and most prosaic. Guston suggested as much when he commented in a 1980 interview, "Sometimes when my painting is getting too artistic, I'll say to myself, 'What if the shoe salesman asked you to paint a shoe in the window?' Suddenly everything lightens. I feel not so responsible and paint directly what the thing is, including the necessary distortions."[12]

The political scene of the 1980s presented plenty of opportunities for Arneson's own necessary distortions.

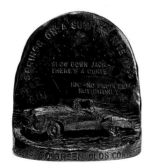

Arneson's political conscience was certainly awakened when his portrait of slain San Francisco Mayor George Moscone was rejected by the city's art commission—the public denunciation of this sculpture played out in the local and national press. Arneson had mounted the portrait bust atop a pedestal marked with inscriptions referring to Dan White, who, in his rampage, had murdered both Moscone and city councilman and gay rights activist Harvey Milk. The markings contain an imprint of a gun, a Twinkie (White pleaded innocent by reason of the "sugar-rush" or "Twinkie defense"), and other graffiti deemed by city officials to be in poor taste.[13] Among the works related to this project is *Oh Danny Boy*, 1983, which,

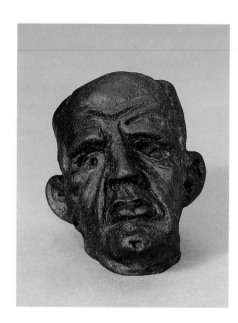

perhaps due to its incendiary subject matter, has not been exhibited before now (cat. 18). A bullet extends from a pistol seen in profile; one can rotate the bullet and have the piece become a music box, playing the traditional Irish tune for which it is named. Producing the work in 1983, after the portrait of Moscone was rejected, Arneson perhaps sought merely to "push the buttons" of his censors with *Oh Danny Boy*. To be sure, it makes a musical toy out of a tragic event in American history. Yet it also relegates gruesome murder to the level of pointless inanity. Not unlike *Toaster, Oh Danny Boy* reduces an otherwise unthinkable and unwieldy event to a controllable, malleable object.

Ronny Portable, 1986, culls forth another set of issues from the 1980s made more manageable when presented as an object (cat. 22). Here, Ronald Reagan's face dominates the interior of a television, his ears protruding from the sides, and his neatly parted hair forming the top of the piece. As early as 1974, Arneson had produced a ceramic television,

into which he inserted a depiction of his own countenance.[14] In the later series, however, we sense that there is no changing the channel. *Ronny Portable* suggests that Arneson had a keen understanding of how modes of communication blur the very messages they carry, and how individuals may manipulate electronic media (as they do artistic media) to produce desired outcomes. A suite of drawings from the Reagan series shows a litany of objects—politician's head, television, jelly bean jars, fluted columns—all contributing equally in the mythologizing process (cat. 20).[15]

Arneson's nuclear series—consisting of 120 drawings, paintings, and works in bronze and clay—addresses the threat of global annihilation which, due to nuclear stockpiling and Reagan's Strategic Defense Initiative, had become a threat in the 1980s. Throughout the series, a villainous general or colonel delivers somber sermons and maniacal messages regarding the world's dire nuclear fate. In *Colonel Nuke's Lecture*, 1984, the once-patriotic American eagle has become a larger-than-life grotesque creature who presents a lecture to the "kids" (cat. 19). As with numerous works in this exhibition, otherwise commonplace objects—toys, cans, appliances, food—take on dire implications, as the eagle-colonel instructs children to "Color what you would need in a shelter." Arneson's source here is a coloring book published in the 1950s as part of a

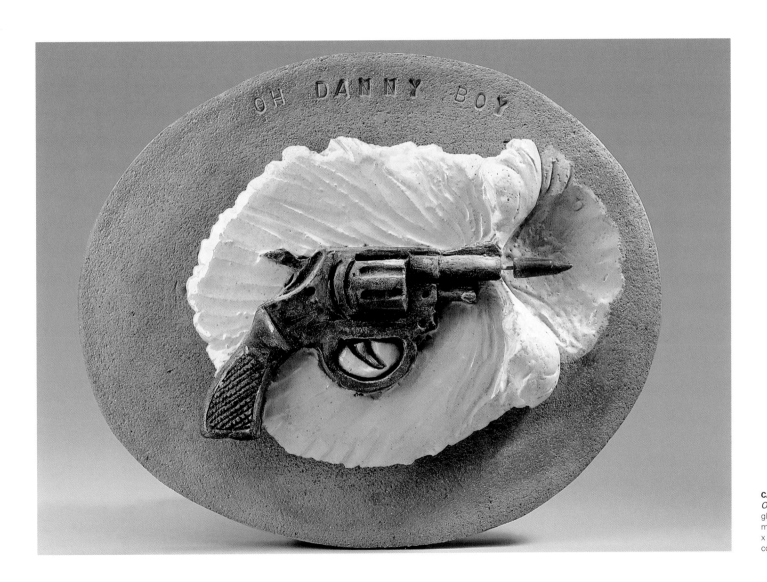

27

CAT. 18
Oh Danny Boy, 1983,
glazed ceramic and
mixed media, 13 x 15 1/2
x 3 1/8 inches. Private
collection.

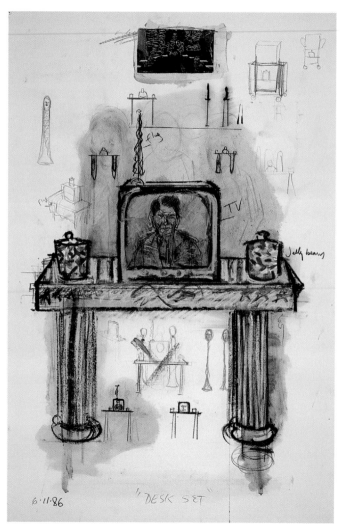

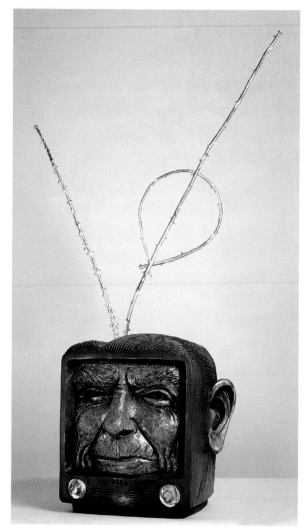

nuclear education program, in which children were asked to imagine life in a bomb shelter.[16]

Given the sheer number of self-portrait busts and masks Arneson produced over his career, it is no coincidence that several exhibitions have highlighted the artist's work in this genre.[17] In a posthumously published interview, artist Carole Windham asked him, "Why do you do so many heads of yourself and why do you distort them?" "I wanted to do heads and abuse them," Arneson responded, adding that, "It's theatre. I can act out a part, make an ass of myself without abusing anyone else."[18] With works like *Head Lamp*, 1970, cast 1992, the artist continued his lifelong transformation of self into a prop in that unfolding drama (cat. 28). The latter is one of several pieces, first modeled in the early 1970s, of which Arneson made bronze versions in the early 1990s (see cat. 27). In re-creating these works, Arneson engaged once more the diaristic "theatre" that formalists like Greenberg and Fried had attempted to remove from pictorial endeavors.

An oft-repeated story recounts Arneson's construction of one of his most important ceramic objects—the first of his toilet pieces, *Funk John*, 1963 (destroyed; fig. 3). One day, while using the restroom at TB-9 (his studio at University of California, Davis), it dawned on him that he was sitting on the "ultimate ceramics in Western civilization." "You can't reflect on art in any way on this thing," Arneson later noted, adding, "and it is 100% ceramics, man."[19] Even more than the toasters, televisions, bricks, and bottles on display in this exhibition, the toilet series illustrates Arneson's ongoing endeavor to collapse the tenuous boundaries between art and craft. It also reminds us to not allow the glare of our "artistic reflections" to blind us from more important matters.

NOTES

1. One can add to this list a corpus of items Arneson incorporated in his work, not as the primary focus, but nonetheless with meaning and purpose: anatomical fragments, arrows, birds, boxing gloves, cigars, columns, dog-food bowls, eggs, eyes, forks, globes, grass, hats, helmets, knives, marbles, needles, paintbrushes, palettes, rats, rockets, stones, skulls, sunglasses, turds, and Twinkies.

2. See Ellen M. Plante, *The American Kitchen, 1700 to the Present: From Hearth to Highrise* (New York: Facts on File, 1995); and Richard Smith, *American Style: Classic Product Design from Airstream to Zippo* (San Francisco: Chronicle Books, 1987).

3. Robert C. Hobbs, "Robert Arneson: Critic of Vanguard Extremism," *Arts Magazine* 62 (November 1987): 88.

4. The subject of whether Arneson's works express political outrage or a larger sensibility of doubt and ambivalence is thoughtfully examined in Hobbs, "Robert Arneson: Critical Clay," *Sculpture* 12 (November–December 1993): 20–25, in which the author assesses exhibitions and scholarship on the artist from the early 1990s, that, according to Hobbs, emphasize politics and propaganda at the expense of a more pervasive skepticism and ambiguity.

5. Donald Kuspit, "Robert Arneson's Sense of Self: Squirming in Procrustean Space," *American Craft* 46 (October–November 1986): 67. Kuspit also observes, in *ibid.*, that "The hand emerging from the *Toaster* ... is like the hand of Lazarus as it reaches out of the tomb."

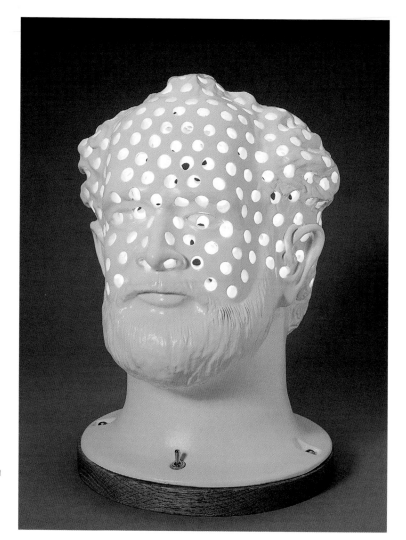

CAT. 28
Head Lamp, 1992,
modeled 1970, painted
bronze and electrical
apparatus, 16 1/4 x
11 1/2 x 11 1/2 inches.
Estate of Robert
Arneson.

6. Arneson may have more in common with Oldenburg than with any other Pop artist. In *The Store* (mixed media installation, 1961–62 [destroyed]) and other works, Oldenburg enlists an inventory of handmade stuff anticipating formal and thematic affinities with Arneson's work of the 1960s and 1970s. Sandra Shannonhouse and Stephen Kaltenbach address Arneson's esteem for Oldenburg in their interview in this catalogue.

7. Of the many modernist-formalist manifestos, two can be singled out for their succinct statement of the ideology: Clement Greenberg, "Avant-Garde and Kitsch" (1939), and *idem.*, "Towards a Newer Laocoon" (1940), in Greenberg, *The Collected Essays and Criticism, Volume I: Perceptions and Judgements, 1939–1944*, ed. John O'Brian (Chicago: The University of Chicago Press, 1988), pp. 522, 2338, respectively. For an especially helpful summary of Greenberg's—and formalism's—legacy, see Henry Sayre, *The Object of Performance: The American Avant-Garde since 1970* (Chicago: The University of Chicago Press, 1989), pp. 6–10.

8. Michael Fried, "Art and Objecthood," in Gregory Battcock, ed., *Minimal Art: A Critical Anthology* (New York: E. P. Dutton & Co., 1968), p. 141.

9. Greenberg frequently voiced what he took to be the superiority of "flat" paintings, works that denied the primacy of depth and linear perspective. So familiar was Arneson with formalist criticism, and Greenberg's "essential flatness" in particular, that in a 1981 interview he referred to one of his nose-flattened-against-picture-plane works from his *Nasal Flat* series as "my Clem Greenberg piece." Arneson, as quoted in Grace Glueck, "A Partner to His Kiln," *New York Times,* May 15, 1981, p. C21.

10. Hilton Kramer, "Ceramic Sculpture and the Taste of California," *New York Times,* December 20, 1981, pp. 31, 33. In an earlier review, Kramer had dubbed Arneson "brilliant," stating that he possessed a "stunning mastery of characterization." *Idem.*, "Sculpture—From Boring to Brilliant," *New York Times,* May 15, 1977, p. D27.

11. For a survey of works of art taking shoes as their subject, see Joseph D. Masheck, "In the Artist's Boots," in *Van Gogh 100* (Westport, Conn.: Greenwood Press, 1996), pp. 295–317. For an argument positing Van Gogh and Warhol's depictions of shoes as, respectively, embodiments of modernism and postmodernism, see Frederic Jameson, *Postmodernism, or, the Cultural Logic of Late Capitalism* (Durham, N.C.: Duke University Press, 1991), p. 79.

12. Philip Guston, in Mark Stevens, "The Artist's Real Subject is Freedom: A Talk with Philip Guston," *The New Republic* 182 (March 15, 1980): 28; as quoted in Bill Berkson, "Pyramid and the Shoe: Philip Guston and the Funnies," in *Philip Guston Retrospective* (Fort Worth: Modern Art Museum of Fort Worth, 2003), pp. 65–73.

13. The details of the fracas have been comprehensively recounted and thoughtfully interpreted in, among other places, Neal Benezra, *Robert Arneson: A Retrospective* (Des Moines: Des Moines Art Center, 1986), pp. 58–63; and Steven A. Nash, *Arneson and Politics* (San Francisco: The Fine Arts Museums of San Francisco, 1993), pp. 12–22.

14. This glazed ceramic piece, called *Color Man* (*Bob on TV*), dates to 1974 and is in a private collection.

15. I find persuasive Steven Nash's suggestion that Arneson's depictions of Muammar Qaddafi, George H. W. Bush, and Ronald Reagan address the questionable nature of authority, the "foibles and failings of leadership"; Nash, p. 22.

16. George Adams, interview with author, November 1998.

17. See, for example, *Robert Arneson: Self-Reflections* (San Francisco: San Francisco Museum of Modern Art, 1997).

18. Carole Windham, "On an Edge," *Ceramic Review* no. 159 (May/June 1996): 38. As early as 1972 Arneson had commented on the "Use and abuse of my own head ..."; Arneson, artist's statement in *Nut Art* (Hayward, Calif.: California State University, Hayward, Art Gallery, 1972), n.p.

19. Beth Coffelt, unpublished interview with Arneson, quoted and discussed in Signe Mayfield, *Big Idea: The Maquettes of Robert Arneson* (Palo Alto, Calif.: Palo Alto Art Center, 2002), p. 27. Arneson produced *Funk John* for the 1963 exhibition *California Sculpture*. See *ibid.* for the work's controversial role in that exhibition, and for its seminal role in Arneson's artistic evolution.

About Bob: An Interview with Stephen Kaltenbach and Sandra Shannonhouse

T HE ARTIST SANDRA SHANNONHOUSE studied at the University of California, Davis, in the late 1960s and early 1970s, where she first met Robert Arneson, to whom she was married from 1973 until his death in November 1992. As overseer of the artist's estate, she has facilitated several Arneson exhibitions and related projects. Stephen Kaltenbach, professor of art at California State University, Sacramento, was Arneson's first student, at Santa Rosa Junior College and then at U.C. Davis. The two remained close friends (they shared a loft in Soho in New York), and Shannonhouse has commented that Kaltenbach had a "huge influence" on Arneson's art and ideas.[1] As Arneson's confidantes and fellow artists, Shannonhouse and Kaltenbach are uniquely poised to address his professional practice in general, and his engagement with the object in particular.

Leo Mazow: In an important essay on Arneson, art historian Robert Hobbs wrote that there is much more to these objects, even the more politically charged ones, than politics and outrage.[2] He argues that they express doubt and ambiguity. What do you think they're about?

Stephen Kaltenbach: They're about Bob.

LM: In what sense?

SK: Bob was always up-front and the objects he made were too. I think this whole thing with the object came from being a potter and being a guy who made objects, and he made them better than anyone else. When I met him in '59, he won every show in California and he was making them and elaborating on the form, but it was still an extremely formal occupation, and once he broke into the idea that objects have connotation and can tell stories, then he was off and running. I think the first things I saw like that were the eviscerated bottles. He was still a potter, but his pots were beginning to tell a story. It's basically the story he ended with, because clay is mortal.

LM: Speaking of mortal clay, works like *Smorgi-Bob, the Cook* (1971, San Francisco Museum of Modern Art), *Oreo Cookie Jar* (private collection), and *Flower Pot Inside* (cat. 10) contain perishables, things that will die or decay, yielding a *vanitas* interpretation. Is there a sense of the transitory nature of life here?

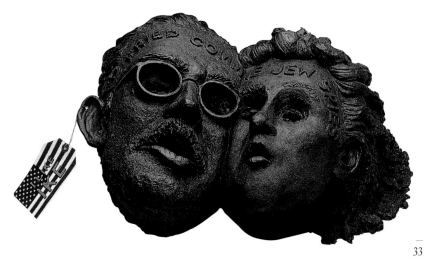

33

Sandra Shannonhouse: I think so, especially after Bob's thinking changed about "life." His diagnosis with cancer in 1975 had to affect him. But I think it was just his nature—he was so full of doubt. There was always that. But there was also politics. He read *The Nation* in graduate school; he listened to the radio station KPFA. And especially after Vietnam—that changed so many of us, and really made everybody take a stand. How could you be a university professor and not take a stand? And then it just went on, and it steamrolled for him. One thing led to another, so it wasn't just one thing. It wasn't just *vanitas* and it wasn't just doubt—but there was always doubt.

34

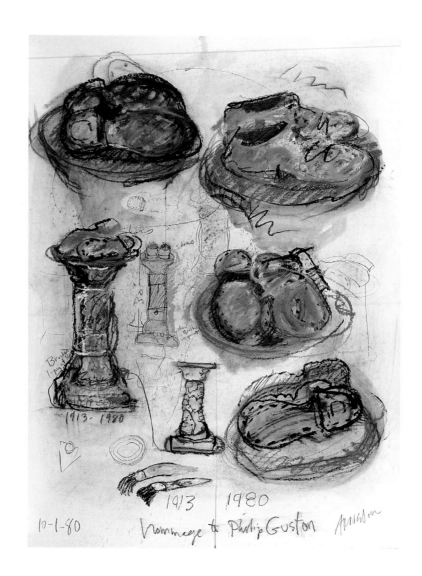

CAT. 16
Study for *Homage to Philip Guston, 1913–1980*, 1980, mixed media, 42 x 32 inches. Prudential Financial.

LM: In calling attention to the tenuous nature of objects and their easy manipulation, was he interested in the duplicitous nature of everyday articles and their ambivalence?

SK: I think he was interested in what the object could say, what he could say through the object. He was interested in expressing his condition, and within that his response to the condition. He always had what I would refer to as a hot response, often sarcastic.

LM: When you look at articles of clothing, coffee cups, appliances, toasters, typewriters in Arneson's work, it's difficult not to hear the din of suburbia.

SS: Well, he was very upset when he had to move to Davis from beautiful Mills College[3], with its much more beautiful surroundings.

SK: Oh, absolutely. He hated suburbia, but also it was like, "Oh my gosh, look what I can do with this material, this clay, I can do more than make a pot with it." And it is really hard to do this kind of thing. And he loved that material. And so one thing kind of begot the other. And then he would like to go back to referencing the pot. All his containers, his coffee cups, his Coke bottles—everything went back to being a potter.

LM: This exhibition features the television piece *Ronny Portable* (cat. 22), and the telephone piece *Call Me Lover* (cat. 4). Can you comment on his interest in television, electrical appliances, and communication devices?

SS: The guy couldn't hear very well. It was a pain in the neck for him.[4] He hated the telephone. *Yellow Call,* for example, is about getting upset, turning yellow and green, every time the telephone would ring and he would have to talk on it. For years it was this way. Finally, hearing-aid technology progressed to a point where it was much easier. So, as Steve said, the objects really are about Bob.

LM: In some of these pieces, it can be difficult to tell whether he is critiquing or celebrating. In *Two Fried Commie Jew Spies* (cat. 23, 24), for example, his stance is not readily apparent.

SS: Well, that piece caused a lot of problems for Bob. Really good friends of Bob's objected to it. This includes the artist Sidney Goodman, who was teaching out here and he came into the studio when that piece was being made; Sidney was really taken aback. You could just see him start to get really upset and then he turned

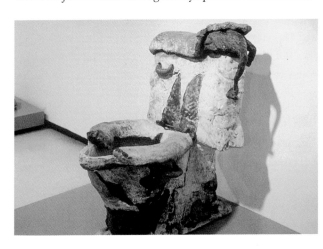

FIG. 3
Funk John, 1963,
(destroyed), ceramic.

and said, "You know, it is hard to tell what you mean here. At first, you're not sure what side you're on." And it was very upsetting. It was really an interesting interchange. And I think Bob wanted that because it makes things more interesting.

SK: It makes things a lot better. There's a razor's edge, and you are right on it, and it is not taking a stance, it's putting a mirror up, making you think, and showing you what you think.

LM: Is this one of the differences between his objects and those of Pop, that the *Toaster* is not just a toaster, the battery in *Two Fried Commie Jew Spies* is not just a battery? These articulate exactly what's missing from much Pop—the human presence.

SS: Exactly. He used to say, "What I do is hot, and Pop is cold."

LM: So, if Arneson saw art and ideas as being one, part of his mission was to make the object carry the weight of ideas?

SK: Objects that speak. Yes. I think all of his best work does this. But it's not always conceptual—a lot of it is emotional. These are containers for human concerns, and some of them are ideas and some of them are emotions.

LM: Can we apply this to, say, *Gold Lustered Rose* (cat. 9)? What is intellectual, versus emotional, here?

SS: Well, as for the big roses, Bob was just trying to figure out a story, what to do. There was some rose/flower catalog, with beautiful looking things, and he just started making these roses. And it became more a thing you can do with clay.

LM: What would you say, broadly considered, is the content of *Homage to Philip Guston* (cat. 15, 16)?

SS: Bob was always trying to find another person besides himself to focus on. That's why he did more than eighty pieces on Pollock. So, for a while, he was working on this Guston stuff. He met Philip Guston when he came out here for his retrospective around 1980. I have photographs of them when they spoke together. It wasn't like they were good friends or anything, but it was right before Guston died. The shoes were made after he died, as a memorial. Bob was always aware of the tradition of upside down shoes as memorials for deceased individuals. I think he did that with Pollock's shoes (see fig. 2).

It's a whole thing about what you do with shoes, their significance in someone's life, and the shoes that are now empty. It was to the extent that, when Bob died, one of us came out to the studio—he used to wear these clogs—and someone came out and turned them upside down on one of Bob's pedestals. You know there's a thing where you put a cowboy's boots, upside down and backwards, in the stirrups when the cowboy dies.

LM: The shoes in *Homage to Philip Guston* look bigger than they in fact are; they refract that strong pink light.

SS: You know Bobby loved that pink glaze.

LM: What about the glaze?

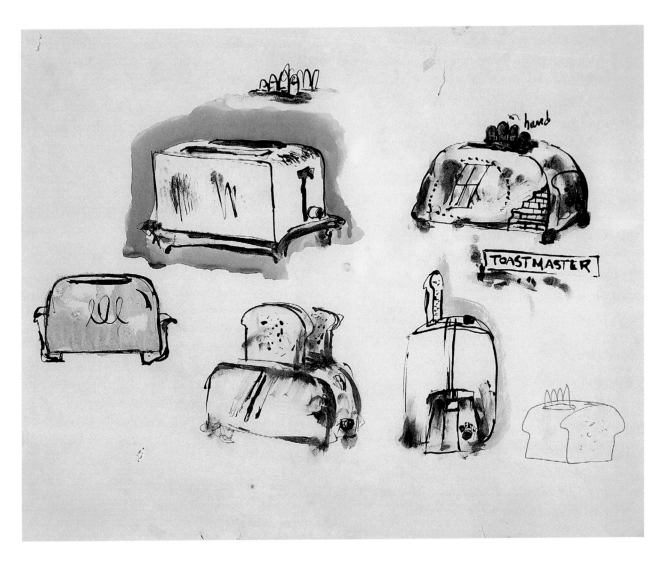

CAT. 2
Toastmaster, 1964,
ink on paper, 18 1/2 x
24 1/2 inches. Private
collection.

SS: That it did all that, refracting the light, and it was so lush. You know you can't get that in any material. I mean, glaze, it's such a luscious thing. He would find a glaze he liked and figure out a way to use it.

LM: Around the time he made a lot of the pieces we're talking about, Clement Greenberg announced that when you put materials from everyday life into your art, it renders it "kitsch." There's also the interview where Arneson acknowledges the critic's predilection for pictorial flatness and aversion against spatial recession, calling one of his truly flat *Nasal Flat* drawings "my Clem Greenberg piece."[5] Did he frequently articulate his knowledge that his work challenged what so many critics called good taste, good art?

SS: Oh yes, he loved it. He just wanted to, you know—it was his job, he took it really personally. It was like, "Let's have a joke on New York." You know, "What are those guys talking about out there?"

LM: So is that series a direct allusion to Greenberg?

SS: I can't say that Bob was thinking about Clem Greenberg when he first made these up-against-the-picture-plane, hard-pressed, flat-nose pieces. But eventually it all fit together. And I think a lot of us do that when we work.

SK: The work speaks back, and we hear, and it becomes an interaction, and the studio shows us where to go.

LM: One of the things that comes to mind here is his self-transformation into a brick (cat. 14, 27). What did the self-as-brick mean to him?

SK: I don't know. I'm not sure it has to go as far as the people who write about art will take it. Bob was also doing ancient history and this, the brick, is a time-honored ceramic object, the cornerstone of civilization. Bob is sort of inserting himself into an honorable ceramic history.

LM: In what ways did Arneson's techniques, his understanding of the nature of clay, impact the meaning of the objects in this exhibition?

SK: You know, Bob was good at what he did, and he seemed to develop a technique to make what he wanted to make when it was necessary. But I always felt—especially once he started making the common object pieces—that his process began to be submerged in the image. Before that, when he was making those geometric forms, and assembling them, around '63 or '64, he was leaving a lot of stitching marks and they were almost a bit decorative and my recollection is that that stopped. Certainly his clay always looked touched. And some of those early toilets have Bob's fingerprints all over the excretions.

LM: It seems he redressed the "touched," that he went out of his way to avoid the slickness of a Pop work. He wanted to remind us that it's not a finished, slick object—that it's handmade.

SK: That's true, but Bob wasn't making a point there, I don't think. He was a master with clay. Clay responded to him in a very intimate way, it always showed his touch, and it was very unselfconscious, as I observed it.

SS: I think you're right. He could never *make* the slick cast objects—well he did some slip casting, but he messed with them, like when he made the celadon pieces. He would mess with them and leave evidence of it having been slip cast, and add handmade, pinched forms or stamped lettering. But he just wouldn't have been interested in a slick object.

LM: You were with him in the early '60s, Steve. What was his reaction to Pop art in general, and Oldenburg in particular, or the "Funk" moniker, for that matter?

SK: There was a general attitude that "dumb" was a compliment, that if something had a dumb look it was a compliment, and we came to associate that with Funk, kind of a goofiness and yet emptiness, almost a Zen dumbness. And Bob did react to other things—I remember comments he made about potters. He wanted to be moving away from "potters," and one of the ways he did it was to be a little bit denigrating toward that craft, which was fine for him. He was giving up something that was very important for him and going into a new area and he needed to do that. But really it didn't go very deep. I remember one of the last conversations we had when he was still at Davis. He was having students just throw; he said "It's such good composition exercise for

them because all they're dealing with is the pure form of the pot." His voice just betrayed the fact that he hadn't changed at all, really. I think it's a really great thing that through all this other stuff he was doing, he still truly loved beauty. And I think his work shows that. Even the most vulgar things that he did have a real presence.

SS: Regarding Oldenburg and Pop ... one of the first books he gave me was *Notes in Hand* by Oldenburg. He loved the lushness of the drawings.

LM: In *Call Me Lover, Binocular,* and several other works, Arneson addressed sexual objectification. How did people respond to these "sex objects?"

SS: There were times in the '70s and '80s when many women who absolutely detested Bob had a really, really difficult time with his kind of in-your-face attitude and took it very personally. We talked about it a lot.

LM: Was any of this spawned by ...

SS: ...Oh, the women's movement. They would attack him. The *Herinal* (fig. 4) was shown at the Memorial Union Art Gallery at U.C. Davis in 1975 and caused a huge ruckus. He had to go into the gallery and defend it. You can just imagine what happened at Davis when that was shown. It got ugly sometimes. Even women faculty members were objecting to it.

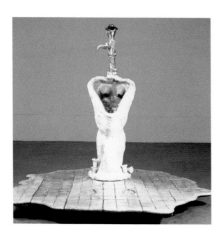

FIG. 4
Herinal, 1965–71, glazed ceramic, without floor, 50 x 15 1/4 x 20 inches, tile floor, 66 x 72 inches. Private collection.

SK: So, in the '60s Bob made a lot of sexualized objects—plus all those bronzes.

SS: Bras, girdles, footballs—combined with other forms and cast, and sometimes painted.

SK: And I never remember anyone reacting to those things at all like that. This was a time of Zap comics, and the culture was extremely sexualized.

I'd like to say that I think a lot of Bob's ability—and I think this is true for a lot of artists—came from his character, not just his personality and his perceptions and so on; he had a very strong character. He had, for instance, the characteristic of honesty, and maybe he would go off the top there. He couldn't possibly have done many of these pieces without being honest because he was talking about himself. That characteristic made him the second most important human male in my life, just after my Dad. Bob affected me not only because he took interest in me, because he helped me and taught me, but because I could really just see who he was. He really made himself available as very few teachers do, and I've been inspired by that, that he made himself available both in terms of time and in terms of being real with it; it made him a very powerful teacher and it's one of the essential reasons he has a lot of successful students, in my opinion.

LM: Could you give me an example of what you mean by "being real," specifically?

SK: Well, you could depend on Bob to tell you the truth about what he thought of your work. All art teachers realize that you are dealing with fragile egos sometimes, and sometimes not. And so it is kind of a holy relationship in a way, you have to be safe—the pain, the reality, the deep reality. Bob was willing to do that, and again he was willing to give the time to do that. He had a great teaching method. He worked in TB-9[6]; he worked and we worked. His studio was always open and we could go in and look at what he was doing and speak to him. He would continue working but would talk to us at the same time. It was very invigorating. I found it to be wonderful and then he let us into his personal life, too. He talked to me on personal terms a number of times and I don't know how much contact you have at the university with professors, but there is usually a pretty big gap between the teacher and the student, and that really didn't exist with Bob.

LM: This exhibition features a few works that relegate Ronald Reagan to a television, an object with a face. Was there something about the '80s that particularly inspired the Reagan and Bush pieces[7], beyond the Strategic Defense Initiative, which obviously influenced the Nuclear series?

SS: Bob was totally incensed by Reagan and Bush—just take a look at those drawings! There was one hanging on the wall in a gallery in Davis last summer, a portrait of George Bush, Sr., and it

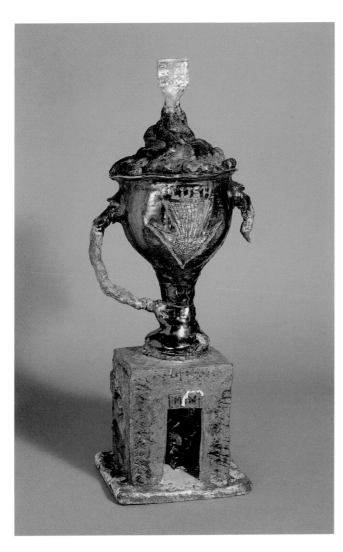

CAT. 5
Flush, 1965, glazed
ceramic, 34 1/8 x
13 x 9 7/8 inches.
Collection of Patti
and Frank Kolodny.

had, "General Baghdad Fucker" on it. Written right on it. It was so timely. We all commented, "Oh my gosh, we forgot about this."

Bob always said that, after the Moscone incident[8], when he realized the power of the press, he then realized he had a platform. And he had an obligation to do work that questioned what was going on. He was deeply concerned about what was going on.

LM: In a work like *Oh Danny Boy* (a reference to Moscone's killer, Dan White) (cat. 18), or even the Twinkie depicted on the pedestal of *Portrait of George* (Moscone), a simple object can tell an entire story. Was he interested in distilling an idea or a story to a single thing?

SS: Or the accretion of things that make up this horrific event (White's assassination of Moscone and Harvey Milk). The Twinkie and the gun. The gun pressed into the pedestal. Yes, and what an object comes to mean.

The above interview is excerpted from a conversation held at the artist's studio, in Benicia, California, in the morning and over lunch, on September 30, 2003. Although this catalogue positions Arneson and his "objects" in several cultural contexts, the comments of his widow and his first student illuminate the manner in which the artist repeatedly invested himself in his work, and the manner in which the objects are, ultimately, about Bob.

NOTES

1. On Shannonhouse and Kaltenbach's early work with Arneson at Davis, see *30 Years of TB-9: A Tribute to Robert Arneson* (Davis, Calif.: John Natsoulas Gallery, 1991), especially pp. 51, 85.

2. Robert Hobbs, "Robert Arneson: Critical Clay," *Sculpture* 12 (November–December 1993): 2025.

3. Arneson received his MFA from Mills in 1958, and taught at the college from 1960 through 1962, when he was hired as assistant professor of art and design at the University of California, Davis. He was promoted to full professor in 1973.

4. On Arneson's congenital hearing loss, see Jonathan Fineberg, "Humor at the Frontier of the Self," in *Robert Arneson: Self Reflections* (San Francisco: San Francisco Museum of Modern Art, 1997), pp. 10, 12, 16.

5. Arneson, as quoted in Grace Glueck, "A Partner to His Kiln," *New York Times*, May 15, 1981, p. C21.

6. The building TB-9, on the campus of the University of California, Davis, housed Arneson's studio and those of his students. See *30 Years of TB-9*, pp. 9–34.

7. Arneson's drawing of George H. W. Bush, called *Wimp Dip* (1991), portrays the President beneath gushing oil on which is inscribed "Gulf Oil." Reproduced in Steven A. Nash, *Arneson and Politics* (San Francisco: The Fine Arts Museums of San Francisco, 1993), p. 23.

8. On Arneson's ill-fated commission for the likenesses of George Moscone and Harvey Milk, see above, pp. 25–26.

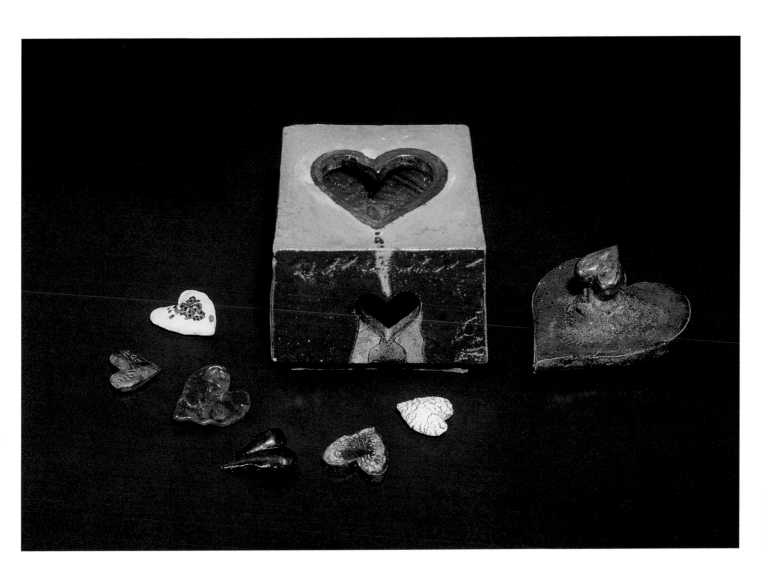

43

CAT. 6
Heart Box, 1965,
glazed ceramic, 5 1/4 x
7 3/8 x 8 1/2 inches.
Collection of Patti and
Frank Kolodny.

Exhibition Checklist

Unless otherwise noted, all works below are by Robert Arneson (1930–1992).

1. *Pee Cola,* 1964
Glazed ceramic
18 3/4 x 9 3/4 x 6 1/4 inches
Private collection, New Jersey

2. *Toastmaster,* 1964
Ink on paper
18 1/2 x 24 1/2 inches
Private collection

3. *Binocular,* 1965
Glazed ceramic
2 x 6 x 6 inches
Private collection

4. *Call Me Lover,* 1965
Glazed ceramic and mixed media
8 x 11 x 9 inches
Private collection, New Jersey

5. *Flush,* 1965
Glazed ceramic
34 1/8 x 13 x 9 7/8 inches
Collection of Patti and
Frank Kolodny

6. *Heart Box,* 1965
Glazed ceramic
5 1/4 x 7 3/8 x 8 1/2 inches
Collection of Patti and Frank Kolodny

7. *Scale,* 1965
Glazed ceramic
14 x 13 x 4 1/2 inches high
Private collection

8. *Toaster,* 1965
Glazed ceramic
8 1/8 x 14 1/2 x 9 3/4 inches
Private collection,
New Jersey

9. *Gold Lustered Rose,* 1966
Glazed ceramic
29 x 24 x 11 inches
George Adams Gallery, New York

10. *Flower Pot Inside,* 1967
Glazed ceramic
9 x 12 x 12 inches
Private collection, courtesy of
George Adams Gallery, New York

11. *Untitled* (Frame #3), 1968
Oil on canvas
26 x 32 inches
Private collection

12. *Eye Screw,* 1971
Glazed ceramic
11 x 8 1/2 x 1 inch
Private collection

13. *Untitled* (coffee cup), 1974
Watercolor on paper
11 x 15 inches
Private collection

14. *Sinking Brick,* 1976
Watercolor on paper
12 x 18 inches
Private collection

15. *Homage to Philip Guston,
1913–1980,* 1980
Glazed ceramic
11 1/2 x 16 x 38 inches (l); 13 1/2
x 18 x 42 inches (r); Private collection,
courtesy of George Adams Gallery,
New York

16. Study for *Homage to
Philip Guston, 1913–1980,* 1980
Mixed media
42 x 32 inches
Prudential Financial

17. Philip Guston (American,
1913–1980),
Group, 1980
Lithograph
29 1/2 x 19 1/2 inches
Palmer Museum of Art,
The Pennsylvania State University

18. *Oh Danny Boy,* 1983
Glazed ceramic and mixed media
13 x 15 1/2 x 3 1/8 inches
Private collection

19. *Colonel Nuke's Lecture,* 1984
Mixed media on canvas
53 x 65 inches
George Adams Gallery,
New York

20. *Desk Set,* 1986
Mixed media and collage on paper
44 1/2 x 30 1/4 inches
Estate of Robert Arneson

21. *Jack—Slow Down,* 1986
Conté crayon and charcoal on paper
30 x 44 1/2 inches
George Adams Gallery, New York

22. *Ronny Portable,* 1986
Bronze
35 1/2 x 21 1/2 x 14 inches
Estate of Robert Arneson

23. *Julius and Ethel with Battery,* 1987–88
Mixed media
30 1/4 x 44 1/2 inches
Estate of Robert Arneson

24. *Two Fried Commie Jew Spies,* 1987–88
Bronze, edition of 3, artist's proof
10 x 22 x 8 1/2 inches
George Adams Gallery, New York

25. *Saga of Jackson Pollock, Bookends,* 1988
Bronze, edition of 10, artist's proof
9 1/4 x 8 1/2 x 4 1/2 inches (each)
Estate of Robert Arneson

26. *Small Pollock Head,* 1990
Bronze
3 1/2 inches high
Estate of Robert Arneson

27. *Brick with Hand of,* 1991, modeled 1972
Bronze
9 1/2 x 8 1/2 x 4 inches
Estate of Robert Arneson

28. *Head Lamp,* 1992, modeled 1970
Painted bronze and electrical apparatus
16 1/4 x 11 1/2 x 11 1/2 inches
Estate of Robert Arneson

Selected Bibliography

Bibliographical note: *The following secondary sources were helpful in organizing the present exhibition and catalogue. See Benezra and Nash, below, for comprehensive bibliographies on Arneson. For primary source material on the artist, see Mady Jones, interview with Robert Arneson, August 1981, Archives of American Art, Smithsonian Institution; Ken Kelly, "Robert Arneson: The Interview," San Francisco Focus (October 1987): 42–58; and Carole Windham, "On an Edge," Ceramic Review no. 159 (May/June 1996): 36–40.*

Benezra, Neal. *Robert Arneson: A Retrospective*. Des Moines: Des Moines Art Center, 1985.

Big Idea: The Maquettes of Robert Arneson. Palo Alto, Calif.: Palo Alto Art Center, 2002.

Fineberg, Jonathan. *Art since 1940: Strategies of Being*. Englewood Cliffs, N.J.: Prentice-Hall, Inc., 1995.

Glueck, Grace. "A Partner to His Kiln." *New York Times* (May 15, 1981): 21C.

Greenberg, Clement. *The Collected Essays and Criticism. Volume I: Perceptions and Judgements, 1939–1944*. Ed. John O'Brian.
 Chicago: The University of Chicago Press, 1988.

Hobbs, Robert. "Robert Arneson: Critic of Vanguard Extremism." *Arts Magazine* 62 (November 1987): 88–93.

_____. "Robert Arneson: Critical Clay." *Sculpture* 12 (November–December 1993): 20–25.

Hobbs, Robert, and Frederick Woodard, eds. *Human Rights/Human Wrongs: Art and Social Change*. Iowa City: University of Iowa Museum of Art, 1986.

Irwin, James. "Censored Clay." *Ceramics Monthly* (February 1982): 32–33.

Kramer, Hilton. "Ceramic Sculpture and the Taste of California." *New York Times* (December 20, 1981): 31, 33.

Kuspit, Donald. "Arneson's Outrage." *Art in America* 73 (May 1985): 134–39.

_____. "Robert Arneson's Sense of Self: Squirming in Procrustean Space." *American Craft* 46 (October–November 1986): 34–37, 64–68.

Nash, Steven A. *Arneson and Politics: A Commemorative Exhibition*. San Francisco: The Fine Arts Museums of San Francisco, 1993.

Philip Guston Retrospective. Fort Worth: Modern Art Museum of Fort Worth, 2003.

Robert Arneson: Self Reflections. San Francisco: San Francisco Museum of Modern Art, 1997.

Sayre, Henry. *The Object of Performance: The American Avant-Garde since 1970*. Chicago: The University of Chicago Press, 1989.